THE
Little Book of
MANITOBA

GEORGE FISCHER

NIMBUS
PUBLISHING LTD

Nimbus Publishing Limited
3660 Strawberry Hill St, Halifax, NS B3K 5A9
(902) 455-4286 nimbus.ca

Printed and bound in Canada

NB1351

Design: Jenn Embree

Library and Archives Canada Cataloguing in Publication

Fischer, George, 1954-, photographer
The little book of Manitoba / George Fischer.
ISBN 978-1-77108-614-1 (hardcover)

1. Manitoba—Pictorial works. . Title. II. Title: Manitoba.

FC3362.F55 2018 971.270022'2 C2017-907911-5

Nimbus Publishing acknowledges the financial support for its publishing activities from the Government of Canada, the Canada Council for the Arts, and from the Province of Nova Scotia. We are pleased to work in partnership with the Province of Nova Scotia to develop and promote our creative industries for the benefit of all Nova Scotians.

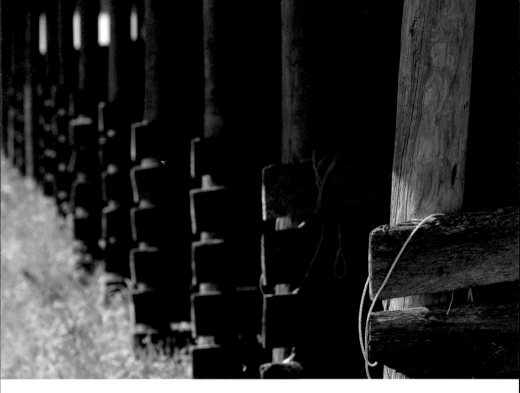

Introduction

THROUGH THE IMAGES ACCUMULATED IN MY TRAVELS TO Manitoba, I have pieced together my heartfelt impressions of this province, which boasts of being "where Canada's heart beats." Rooted in Indigenous legend and vast natural gifts, Manitoba offers diverse geometry and unique compositions. It contains flashes of architectural brilliance and passionate people's art. Through road trips and helicopter flights, I have composed a collection of enduring impressions to take you on an inspiring journey to the "narrows of the Great Spirit."

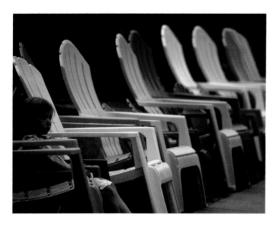

ABOVE ∾ A young lady contemplates life in a row of neon chairs. (Wasagaming)

The human side

Manitoba has embraced its rich and diverse past. In the heart of downtown Winnipeg, The Forks is rooted in six thousand years of meetings among Indigenous peoples and Métis, European traders and settlers, bear and buffalo hunters, riverboat and railway workers, pioneers and immigrants. At the confluence of the Assiniboine and Red Rivers, it is now one of Canada's National Historic Sites where more than four million visitors annually shop, dine, party, and absorb the culture of Winnipeg—which has, according to Statistics Canada, the largest Indigenous population of any major Canadian city.

Manitoba's history includes periods of architectural innovation, and today historic landmarks rub shoulders with contemporary designs. The imposing twentieth-century Canadian Pacific Railway Station in Winnipeg contrasts sharply with the Prairie Dog Central Railway stations for steam locomotives, and humble country whistle stops. And the glossy giant that is the Museum for Human Rights evokes the spirit of the Prairies and symbolizes Canada's dedication to human rights and learning.

Across the region, monuments and museums speak to Manitoba's multicultural history. The folk narrative is preserved in everything from architecture and art to music, dance, and ethnic festivals.

The wild side

The bedrock of the province is the Precambrian Shield. Ice-smoothed hills and rough-hewn basins filled with lakes consort with powerful waterfalls cascading through rocks and forests.

Sand dunes shift and provide abodes for cacti and snakes. Rolling hills, valleys, forests, and meadows sculpt the escarpment, where wildlife and humans roam. In Altona, the humble sunflower is even celebrated with its own annual festival.

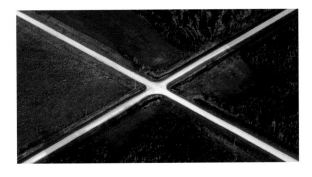

ABOVE ∻ A bright crossroads cuts a straight swath through fresh fields. (Near Edrans)

Countless species form the province's ecosystem: polar bears, beluga whales, caribou, elk, eagles, and cranes —even black bears like the legendary Winnie the Pooh, which owes its name to the Manitoba capital. The A. A. Milne character was based on a real bear brought to London by a Canadian soldier.

Churchill is known as the "Polar Bear Capital of the World," and visitors flock there to view the great white creatures. But the northern town is also a beluga whale–watching hot spot and birders' paradise.

My side

Manitoba is shaped by westerly winds and Arctic waters, boreal forests and the Canadian Shield. The human side adds heritage and artistry, agriculture and commerce. For me, the cultural experience included finding comfort zones in a region where temperatures in winter can drop to -40°C. I gravitated toward amazing eateries and luxuriated in a spa that offers a two-thousand-year-old Nordic ritual of hot and cold therapy. In summer, when temperatures can climb well into the 30s, I found warm spots in the sun, under whose rays visitors can go camping in tents and Mongolian yurts or benefit from authentic learning experiences at guest farms and ranches. All of this heightened my appreciaton for this resilient province brimming with heart.

—George Fischer

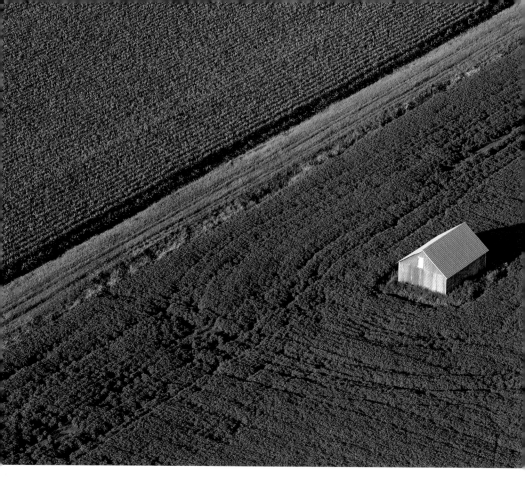

ABOVE :~ Just south of the Trans-Canada Highway, a faded barn seems to have been dropped into the middle of a verdant field. (Near MacGregor)

FACING :~ An aerial view presents a quilt-like patchwork of fields divided by the Assiniboine River. (Near Rossendale)

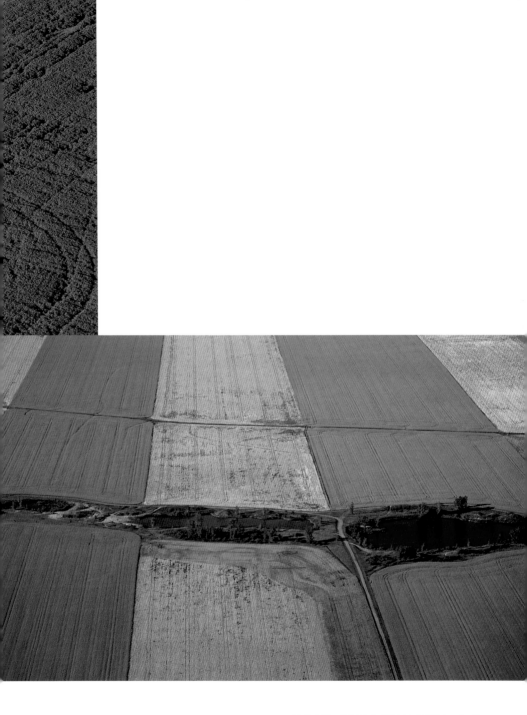

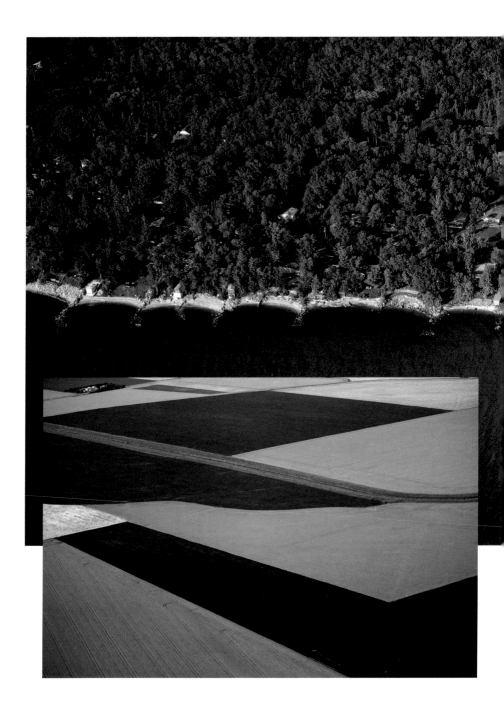

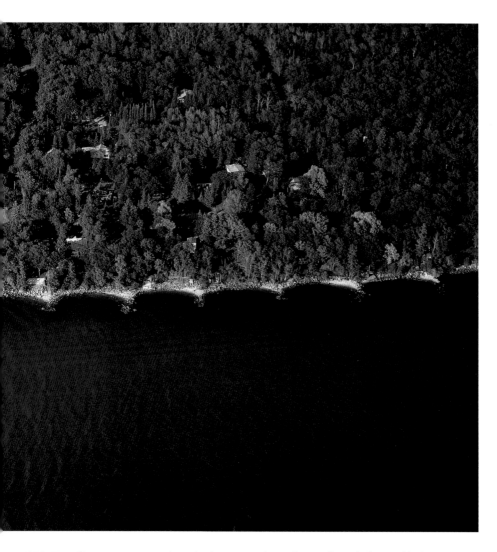

ABOVE :~ Cottages are set deep in the trees along the scalloped shore of Lake Winnipeg. (Near Balsam Harbour)

FACING :~ The Central Plains Region shows off a picturesque patchwork of fields. (Near Portage la Prairie)

OVERLEAF :~ The Assiniboine River, mirroring a clear sky, snakes through farm country from Saskatchewan across most of Manitoba. (Near Lavenham)

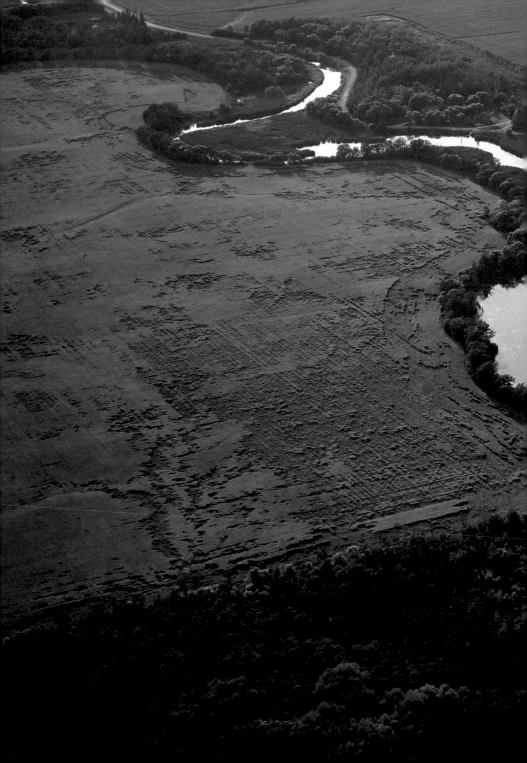

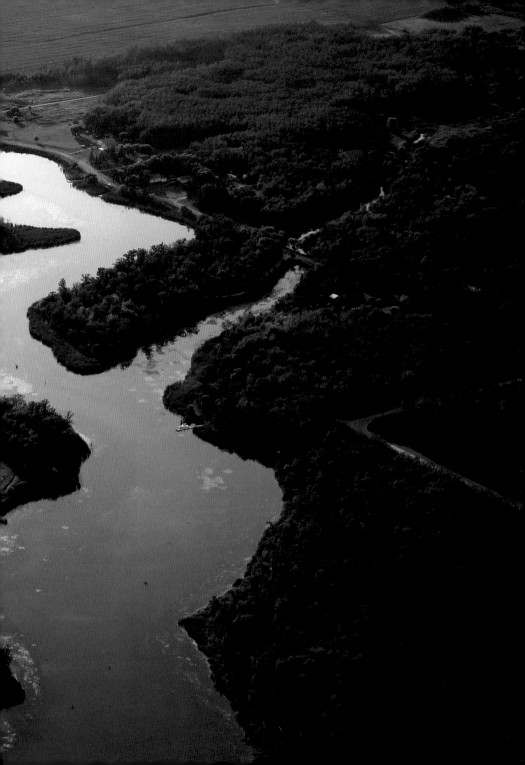

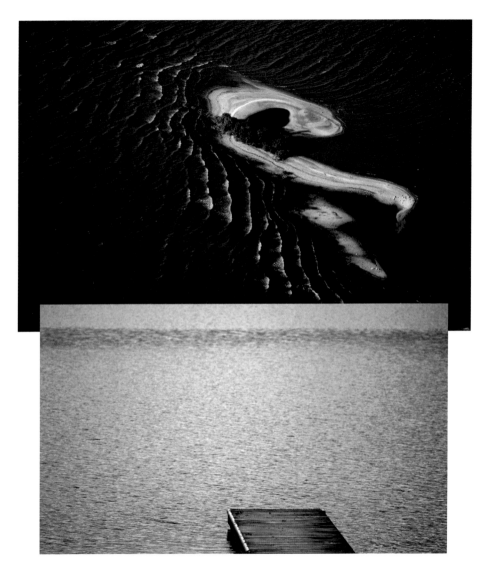

ABOVE :~ Relentless waves on Lake Winnipeg march upon a defenceless sandbar inhabited only by birds. (Near Grand Marais)

BELOW :~ A dock at Lake Audy promises to melt away stress. (Wasagaming)

FACING :~ Each year Dunnottar's Piers are built for the summer months and removed in the fall before Lake Winnipeg ices up. (Near Dunnottar)

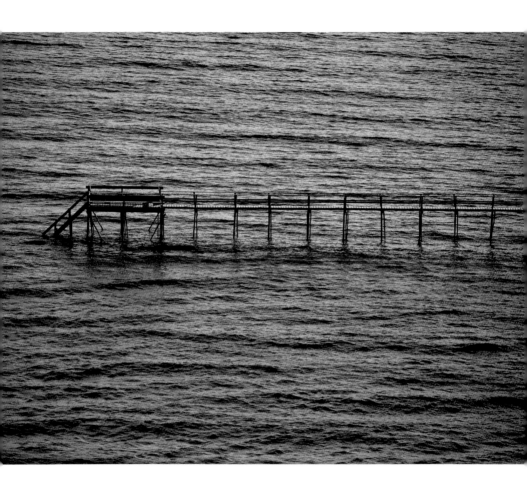

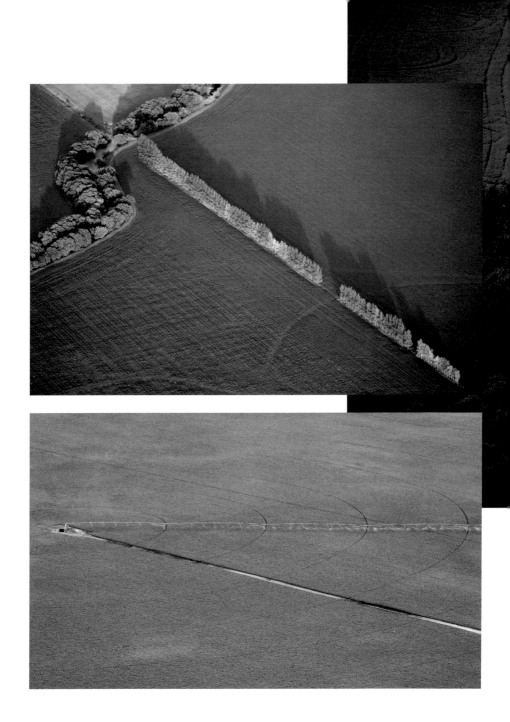

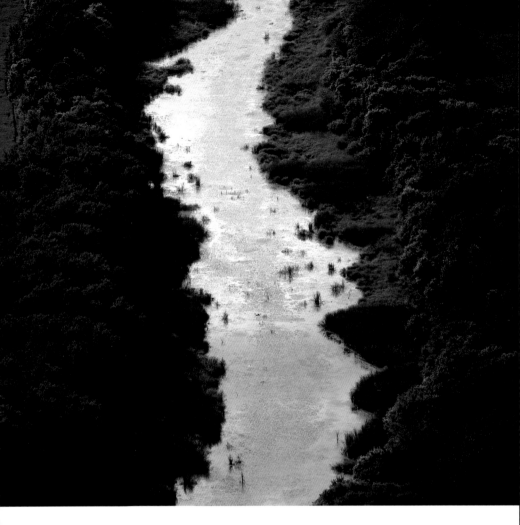

ABOVE :~ Mature trees encroach upon the Assiniboine River (named after the Assiniboine First Nation) as it moves along its route. (Near Stockton)

FACING ABOVE :~ Stands of trees clearly delineate agricultural boundaries. The area is close to the United States border and North Dakota. (Near Rathwell)

FACING BELOW :~ A flawless agricultural carpet is marred by a large-scale irrigation system. (Near St. Eustache)

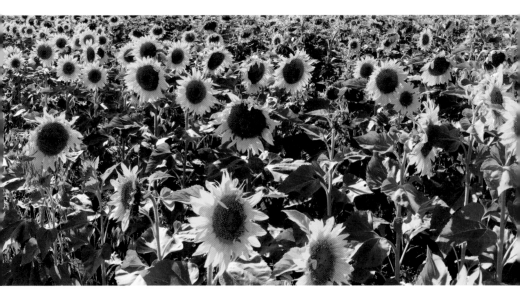

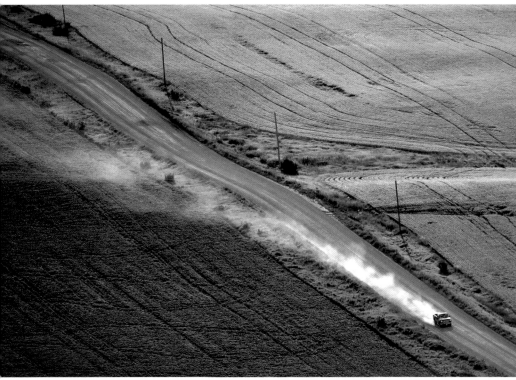

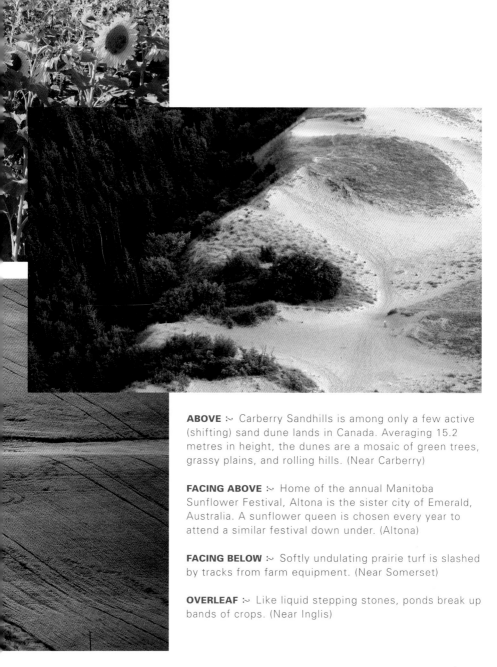

ABOVE :~ Carberry Sandhills is among only a few active (shifting) sand dune lands in Canada. Averaging 15.2 metres in height, the dunes are a mosaic of green trees, grassy plains, and rolling hills. (Near Carberry)

FACING ABOVE :~ Home of the annual Manitoba Sunflower Festival, Altona is the sister city of Emerald, Australia. A sunflower queen is chosen every year to attend a similar festival down under. (Altona)

FACING BELOW :~ Softly undulating prairie turf is slashed by tracks from farm equipment. (Near Somerset)

OVERLEAF :~ Like liquid stepping stones, ponds break up bands of crops. (Near Inglis)

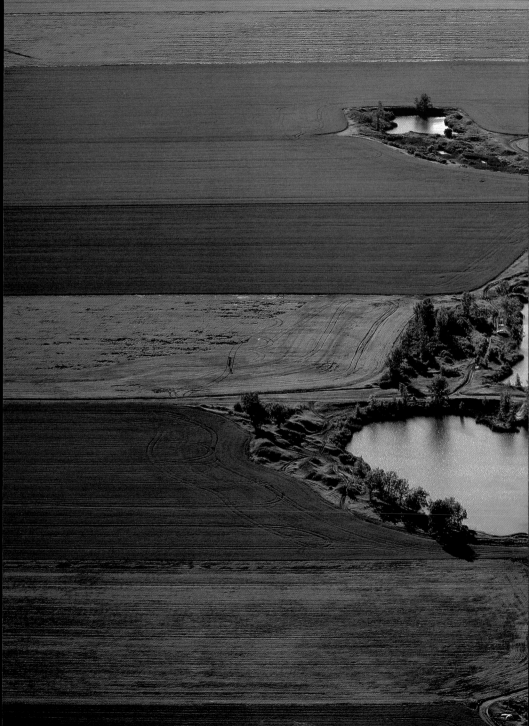

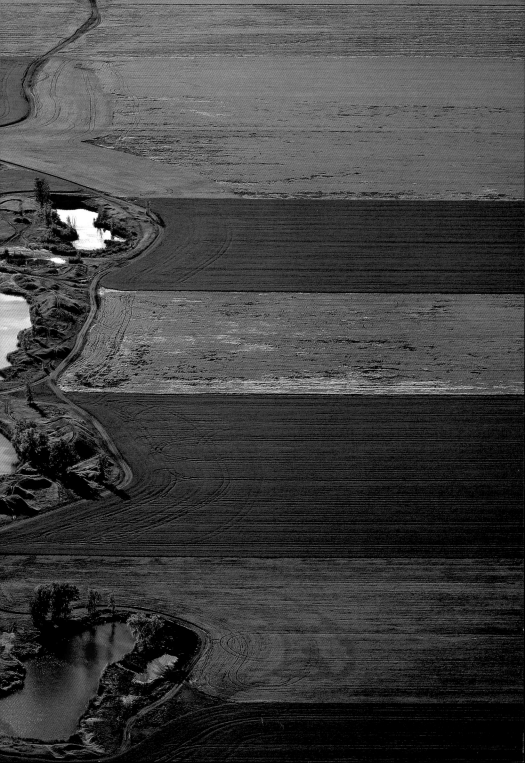

FACING :~ Canada's sixth-largest freshwater body, Lake Winnipeg is the nation's largest watershed. (Winnipeg)

BELOW :~ Rolling hills weave a highly textured rural tapestry. (Somerset)

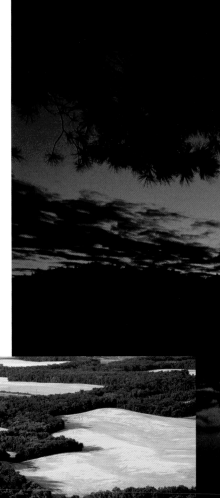

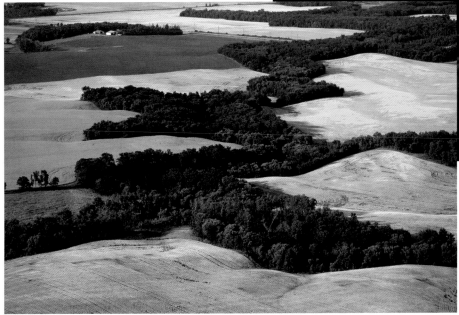

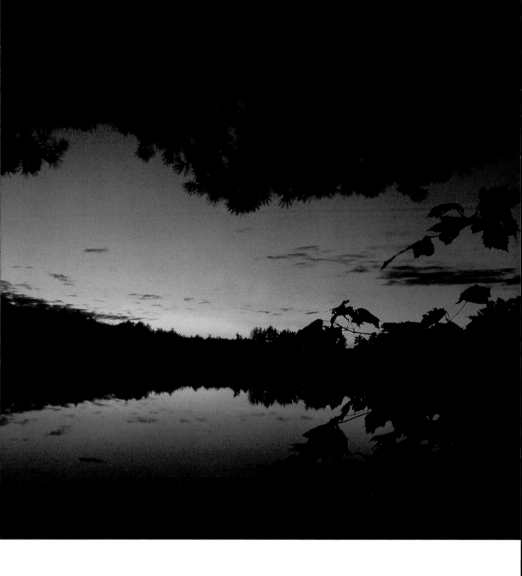

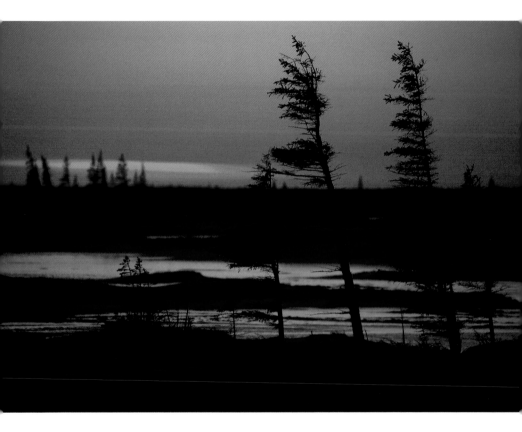

ABOVE ∿ A vibrant sunset silhouettes trees in Wapusk National Park. Their irregular shapes are formed by strong winds hitting them predominantly from one direction. (Between Churchill and Port Nelson)

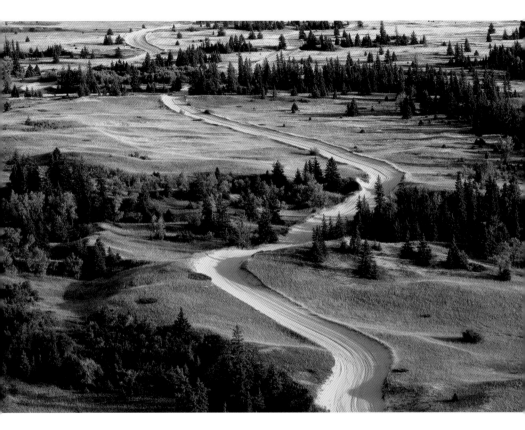

ABOVE ∿ A relaxed road sweeps through Spruce Woods Provincial Park, dedicated to preserving the Assiniboine Delta Natural Region, as well as providing recreation for visitors. (Near Little Plain)

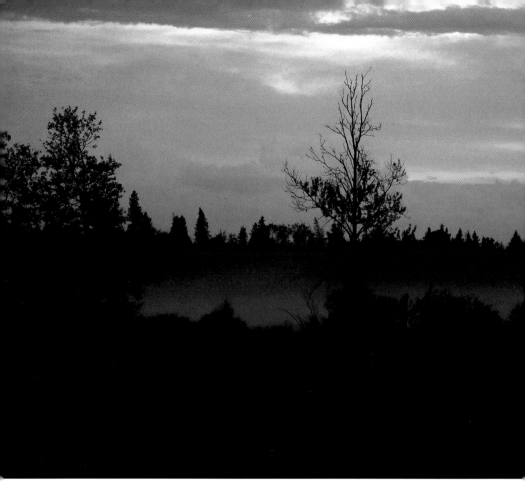

ABOVE :~ A cloak of fog adds an air of mystery to Lake Audy in Riding Mountain National Park. (Wasagaming)

FACING :~ In the 1930s, plains bison were reintroduced to Riding Mountain National Park, once part of their range. Now almost extinct, bison in North America initially numbered more than 25 million. (Wasagaming)

OVERLEAF :~ Protected forests in Riding Mountain National Park add an artful element to the area. The park sits on the Manitoba Escarpment (also known as the Pembina Escarpment) that spans the Dakotas and Manitoba. (Wasagaming)

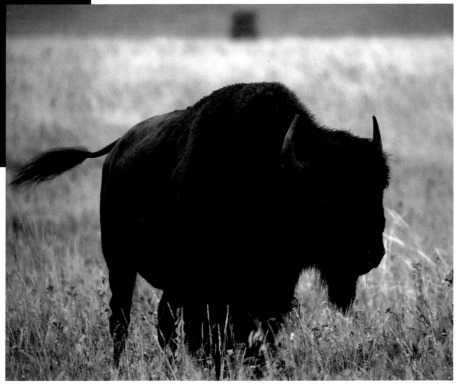

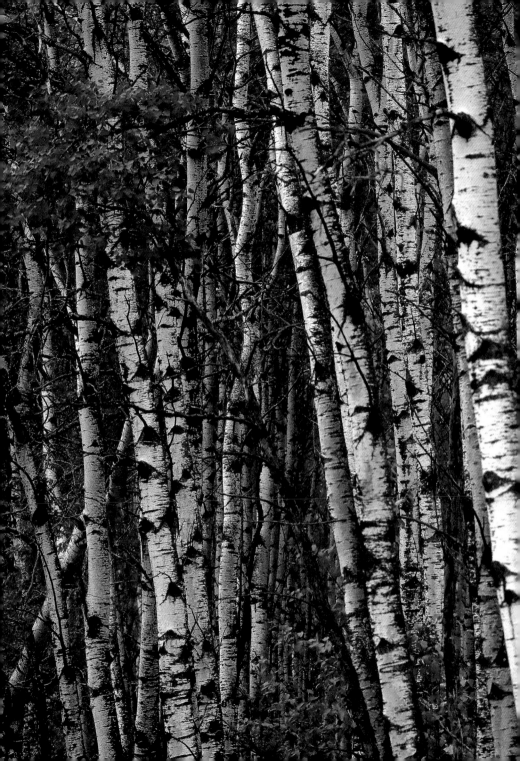

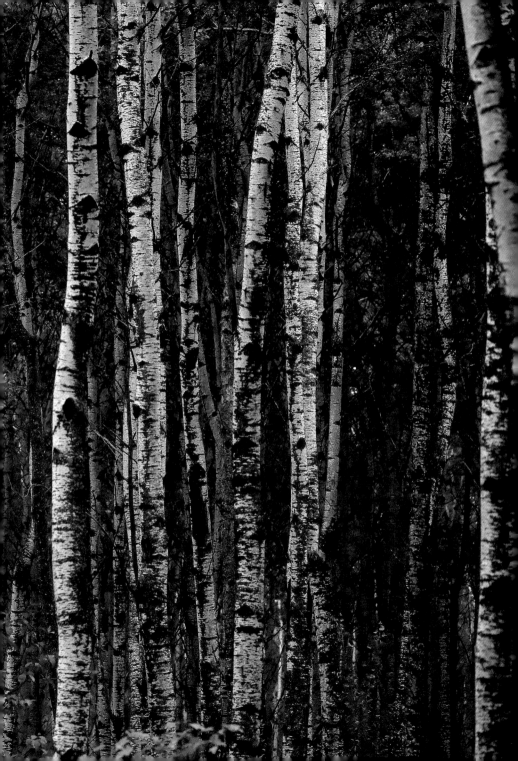

BELOW :~ Grand Beach is a wonderful freshwater destination for a day trip, with amenities close by. During the early 1900s, Manitobans working on the Canadian Northern Railway development were among the first to discover its charm. (Grand Marais)

FACING ABOVE :~ The CN Railway Bridge spans the Red River at Emerson, named after writer Ralph Waldo Emerson. The small Manitoba municipality borders Minnesota and North Dakota. (Emerson)

FACING BELOW :~ An elaborate medieval castle and fortifications pop up on the shore of Clear Lake. (Wasagaming)

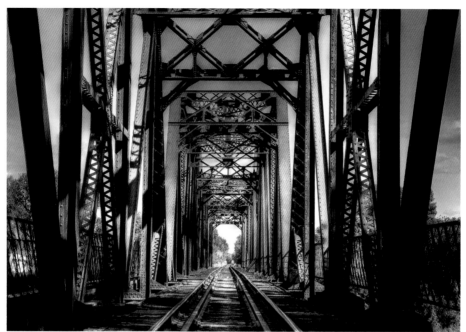

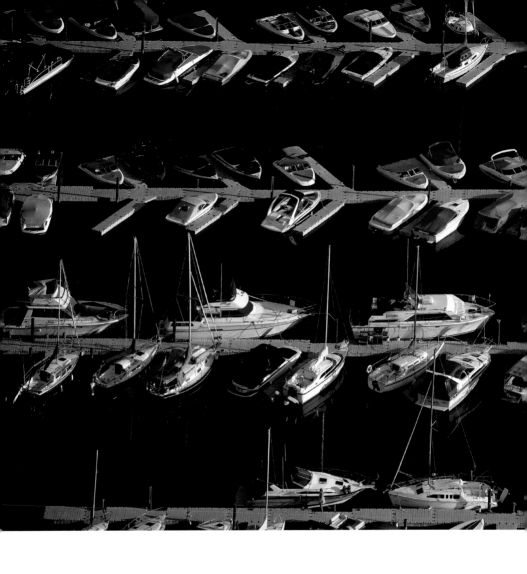

FACING :~ Docked at Boundary Creek Marina, all types of watercraft are ready for sailing, windsurfing, cruising, and fishing on Lake Winnipeg. (Winnipeg Beach)

BELOW :~ Summer activities engage visitors beyond the boardwalk at Clear Lake in Riding Mountain National Park, which has a great deal to offer visitors. (Wasagaming)

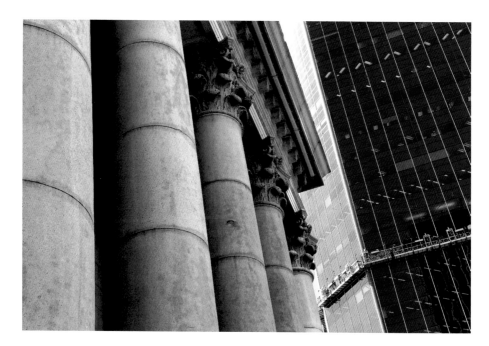

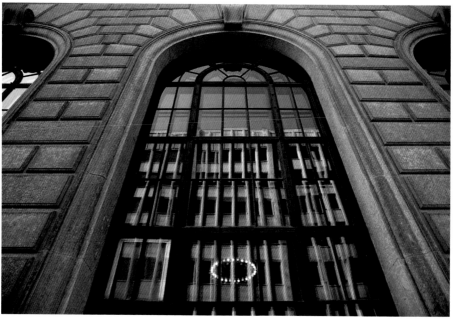

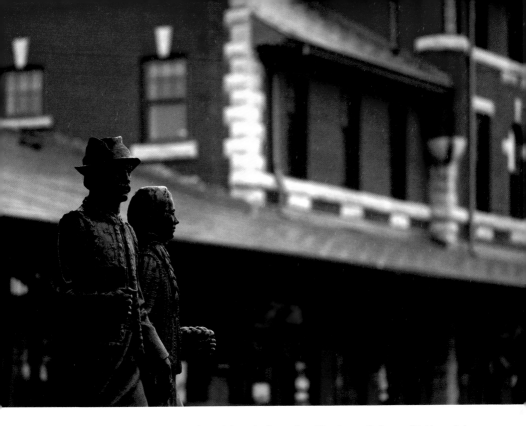

ABOVE :~ Against the backdrop of the historic Canadian Northern Railway Station, John Weaver's sculpture *Young Pioneers* commemorates the optimism of early Ukrainian settlers whose unflinching spirit helped build this part of Western Canada. (Dauphin)

FACING ABOVE :~ Old meets new on the corner of Portage and Main, where dignified Bank of Montreal columns contrast against the geometric blue glass of the thirty-four-storey Richardson Building office tower. (Winnipeg)

FACING BELOW :~ Built during prosperous years in the early 1900s, the Bank of Hamilton Building stood along "Bankers' Row" on Main Street. In 1923, the company merged with the Bank of Commerce. (Winnipeg)

OVERLEAF :~ The Millennium Centre is undergoing significant restoration and preservation. Formerly the Canadian Bank of Commerce, it has been designated a Grade I Heritage Building. (Winnipeg)

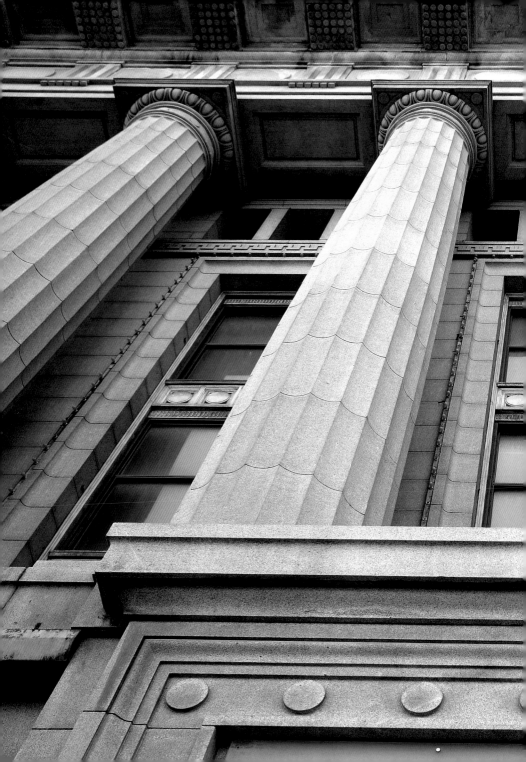

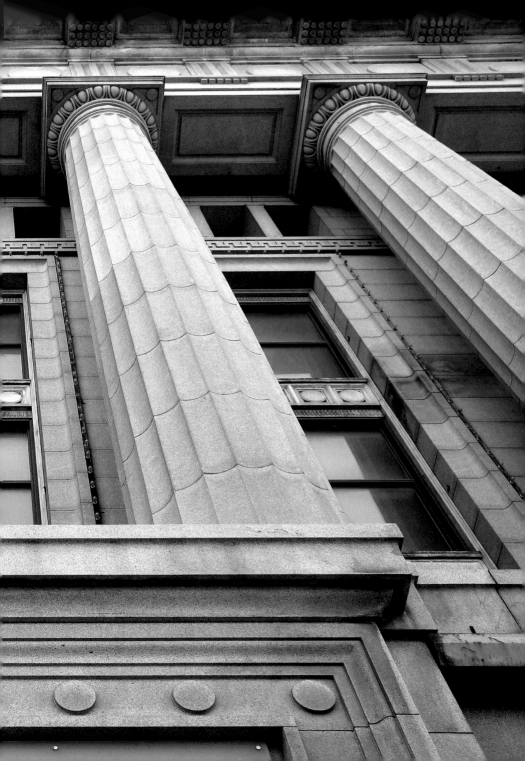

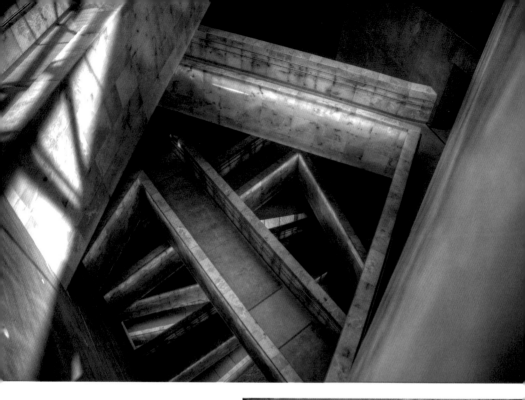

ABOVE ∶∿ Pale alabaster softens the sharp angles of pedestrian ramps in the Canadian Museum for Human Rights. From ground to sky, they stretch eight storeys in a metaphorical human journey from darkness to light. (Winnipeg)

BELOW ∶∿ Glamorous detail draws the eye upward on a tour of the Exchange District. (Winnipeg)

FACING ABOVE ∶∿ Unique structural details of the Precious Blood Roman Catholic Church comprise a recognizable landmark. (Winnipeg)

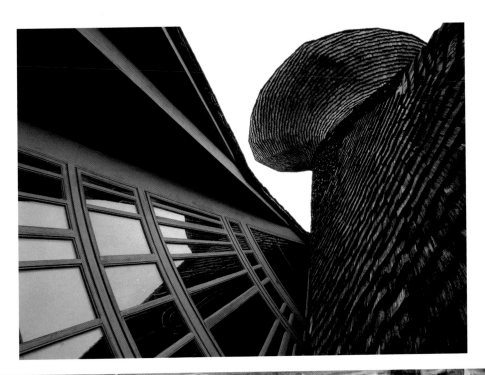

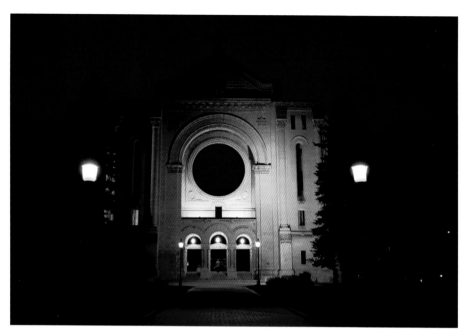

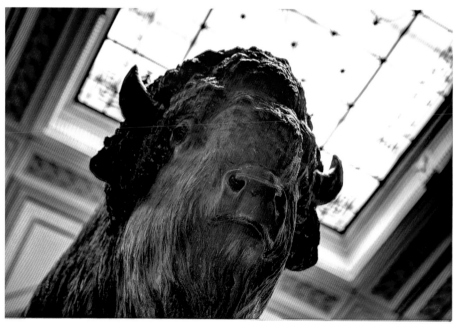

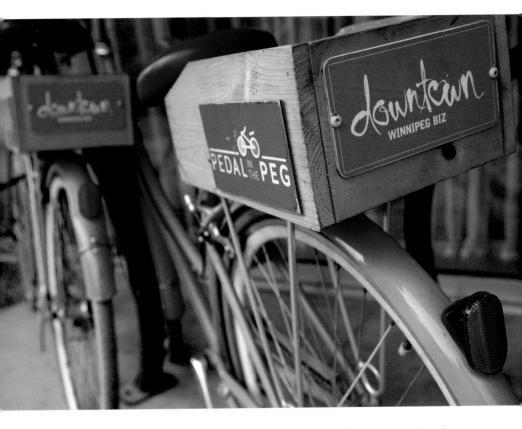

ABOVE ∻ The Pedal in the Peg bike rental program has gained momentum since it launched in 2015. Businesses and hotels participate to help reduce downtown pollution. (Winnipeg)

FACING ABOVE ∻ Remains of the St. Boniface Cathedral in the French district cast a haunting beauty on the limestone facade and empty rose window. (Winnipeg)

FACING BELOW ∻ Flanking the grand staircase, a pair of plains bison guard the entrance to the legislative chamber. Cast in bronze, each life-sized bison weighs 2,268 kilograms. (Winnipeg)

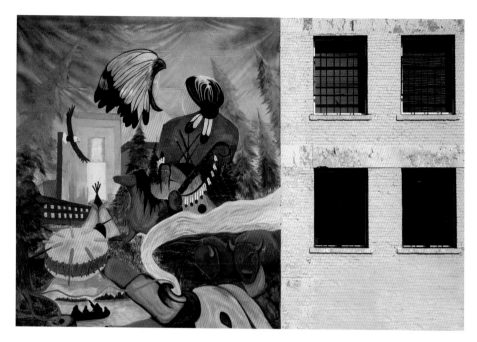

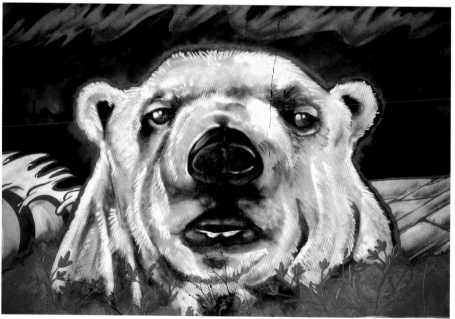

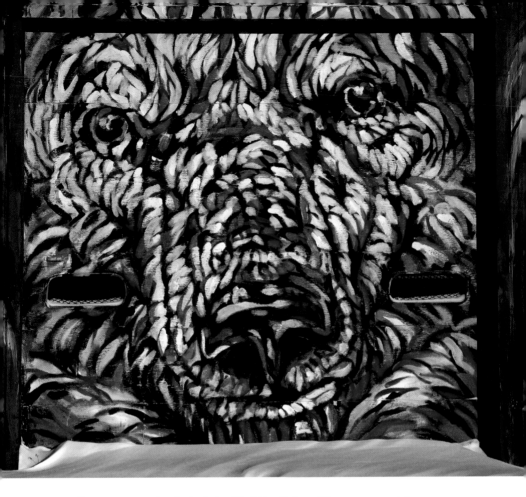

ABOVE :~ *Encounters at the End of the World* by Kelsey Eliasson, one of the artists who came to Churchill in 2017 and painted vibrant murals promoting the environment. (Churchill)

FACING ABOVE :~ Celebrating the contributions and culture of First Nations peoples, artists at the Graffiti Gallery in 2005 unveiled their vinyl mural, which is affixed to the Indigenous and Northern Affairs building. (Winnipeg)

FACING BELOW :~ *Hopeful Waiting* by Pat Lazo, who was involved in the early Canadian graffiti movement. (Churchill)

OVERLEAF :~ An interior spiral lines the tipi-inspired roof of the Precious Blood Roman Catholic Church, designed by Étienne Gaboury (also designer of the Royal Canadian Mint). (Winnipeg)

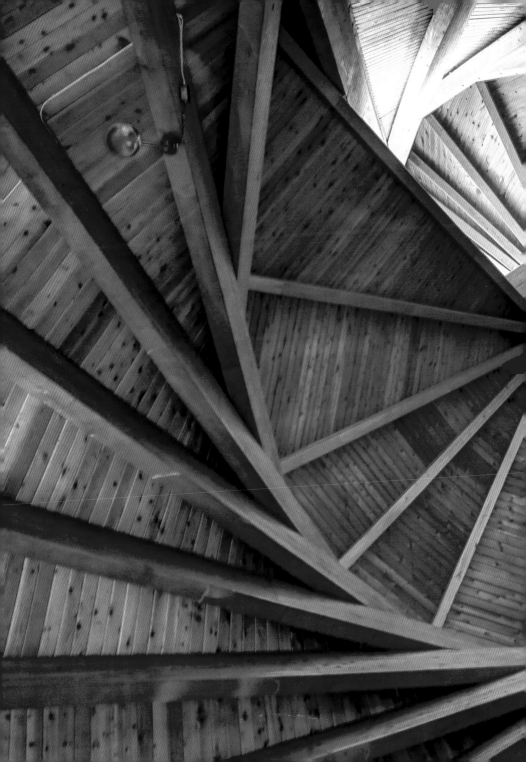

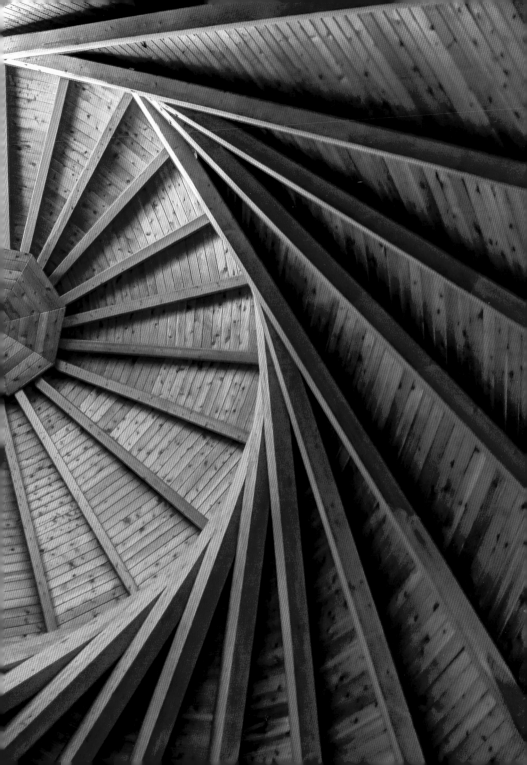

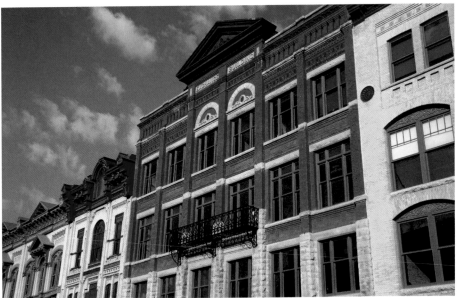

ABOVE :~ A full-sized carving of a Red River cart engages visitors of the Manitoba Liquor & Lotteries Heritage Wall at Upper Fort Garry Provincial Park. (Winnipeg)

BELOW :~ Erected in 1898, the refurbished Grain Exchange Building and adjoining buildings make up one of Canada's oldest streetscapes. (Winnipeg)

FACING :~ Rows of parallel balconies strike a linear mosaic on the side of a skyscraper on Portage Street. (Winnipeg)

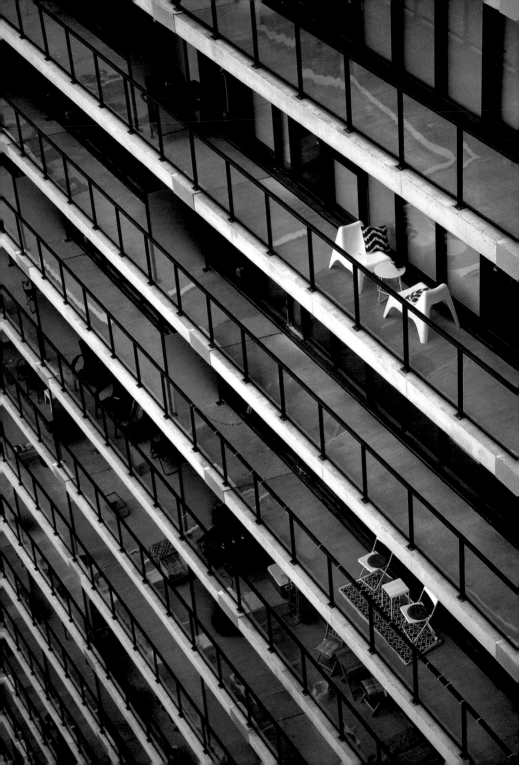

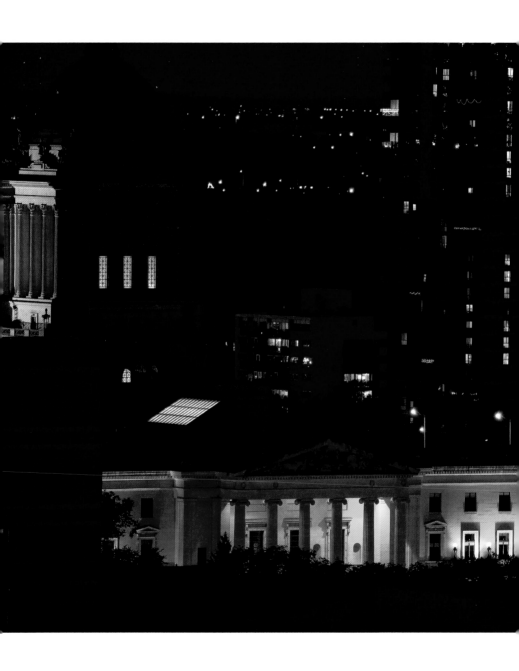

ABOVE :~ Originally built by the Canadian National Railway, Churchill Station has been restored. It is now a National Heritage Site with elements of the Queen Anne Revival and Arts and Crafts styles and remains an active Via Rail passenger station. (Churchill)

FACING :~ Warm lights define the neoclassical architecture of the Manitoba Legislative Building. Designed by Frank Worthington Simon and Henry Boddington III, the structure was completed in 1920, seven years after it was started. (Winnipeg)

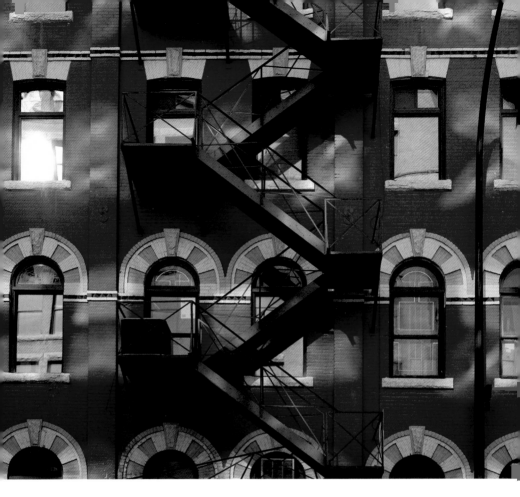

ABOVE :~ Designed in 1893 by Hugh McCowan for the Stovel Company printing business and sold in 1940 to dry goods firm Kay's Limited, this six-storey Romanesque Revival warehouse is now a municipally designated historic site. (Winnipeg)

FACING ABOVE :~ Bell MTS Place officially opened in November 2004 on the site of the historic Eaton's department store. In a nostalgic farewell to the famous landmark before its demolition,180 people gave the store a "group hug." (Winnipeg)

FACING BELOW :~ Parlour Coffee offers a quality brew featuring specialty roasts from excellent sources. (Winnipeg)

OVERLEAF :~ *The Last Winter*, a mural painted by Spanish artist Dulk, represents the journey of a family of bears and belugas in their last winter on Earth. (Churchill)

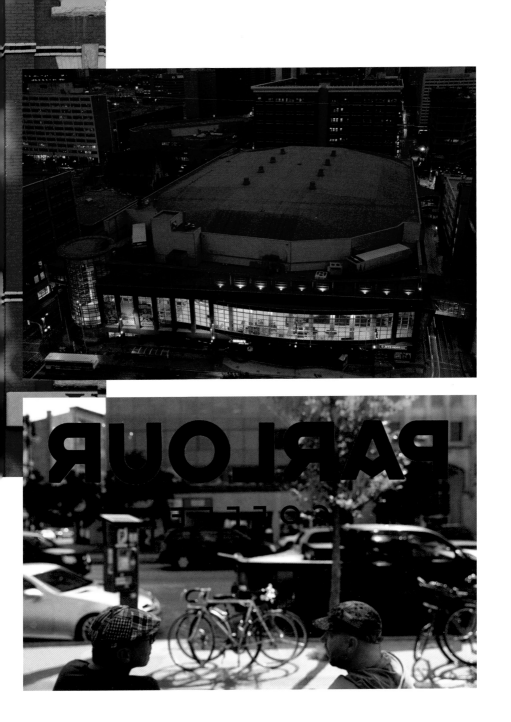

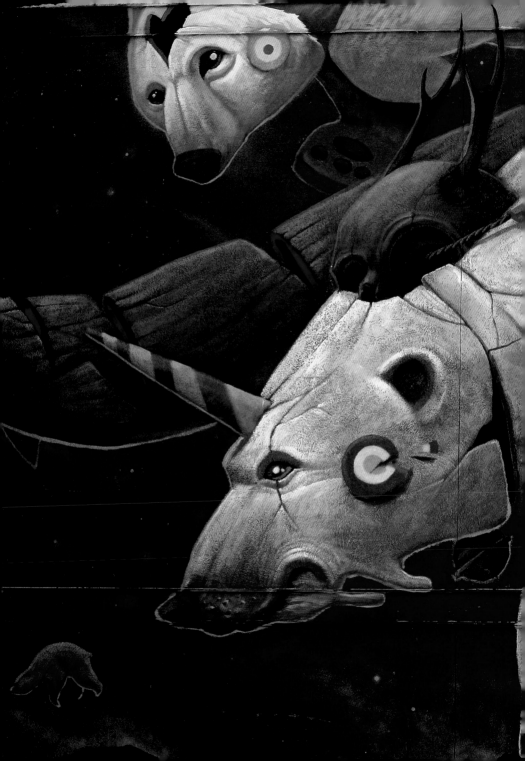

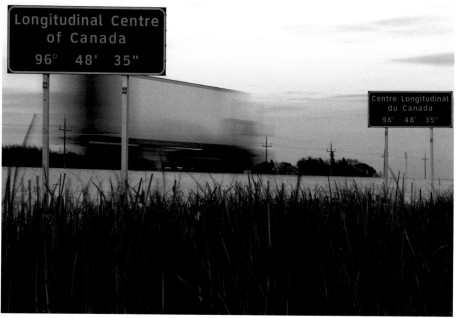

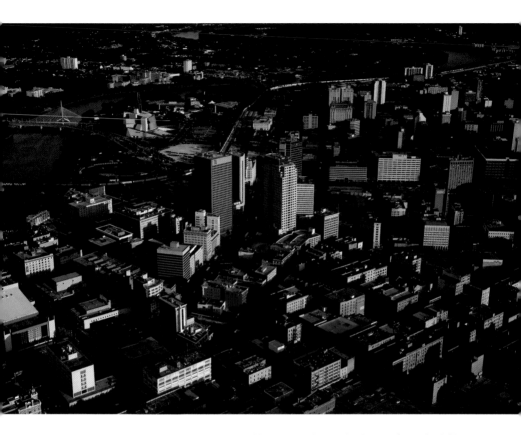

ABOVE :~ Home to some 700,000 residents, Winnipeg sits at the base of the Red River Valley flood plain. (Winnipeg)

FACING ABOVE :~ Illuminated indicators on a Canadian National Railway engine make trainspotting a little easier. (Near Landmark)

FACING BELOW :~ The exact centre of Canada is a tough one to calculate but Manitoba lays claim to being the east-west centre. (Taché)

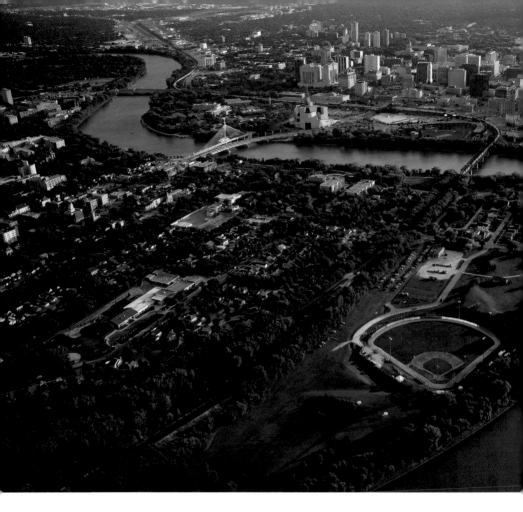

ABOVE ∿ The Red River winds lazily past famous landmarks: Whittier Park in St. Boniface, the rail bridge, the vehicular Provencher Bridge, and the Esplanade Riel pedestrian bridge. (Winnipeg)

FACING ABOVE ∿ An elevated view of a downtown office building reveals artfully detailed brickwork. (Winnipeg)

FACING BELOW ∿ The domed centrepiece of the antechamber in the Manitoba Legislative Building hovers above four sets of towering Corinthian columns. (Winnipeg)

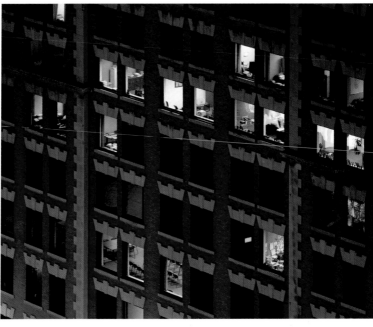

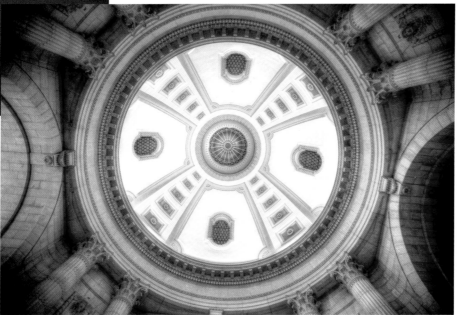

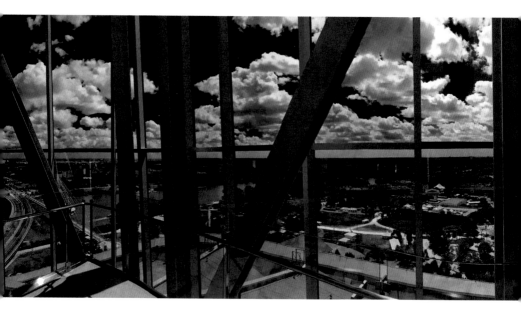

ABOVE :~ Panoramic views from the twenty-three-storey glass spire of the Tower of Hope atop the Canadian Museum for Human Rights stimulate thoughts of enlightenment. (Winnipeg)

FACING BELOW :~ The reflection of the iconic Esplanade Riel pedestrian bridge glows in the Red River. Left, the Canadian Museum for Human Rights stakes its claim next to The Forks, where the Red and Assiniboine Rivers converge. (Winnipeg)

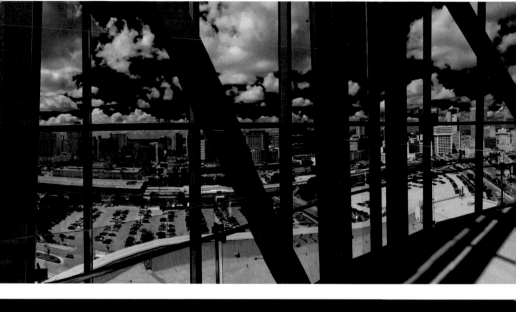

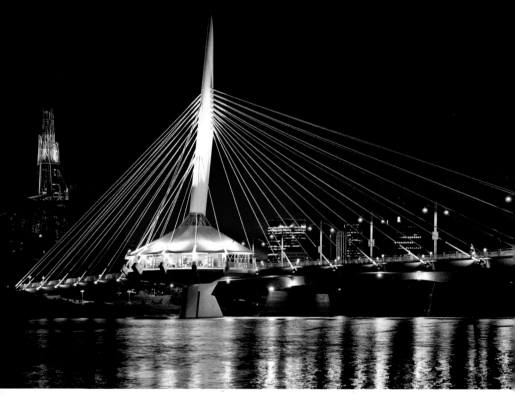

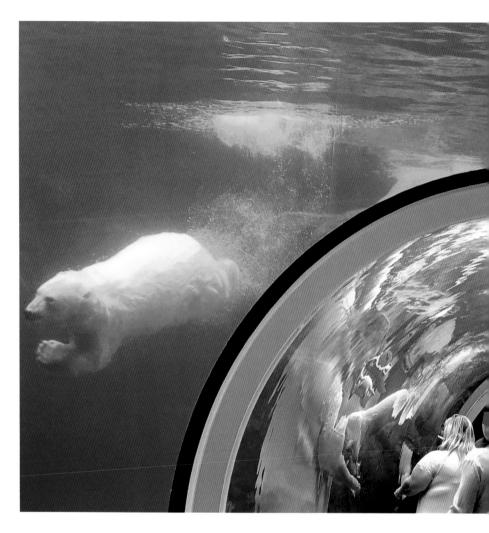

ABOVE :~ Visitors in underground viewing tunnels come close to nature at Assiniboine Park Zoo. At the Sea Ice Passage, polar bears and seals swim overhead. (Winnipeg)

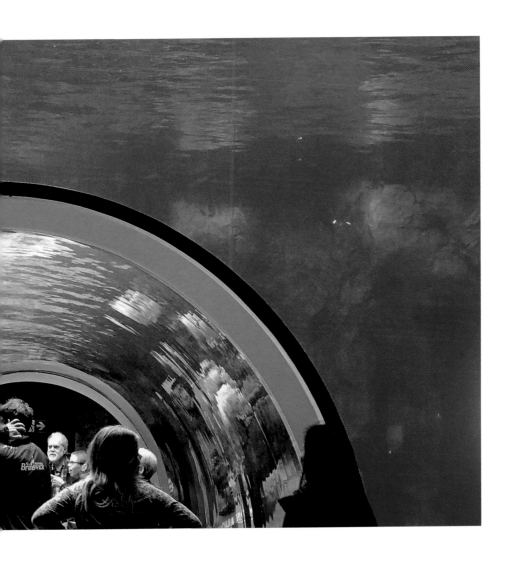

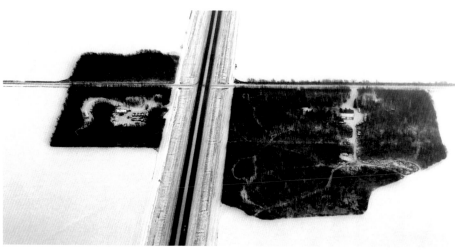

ABOVE :~ Polar bears have an acute sense of smell and can detect seals under a metre of snow and ice. (Churchill)

BELOW :~ Isolated farms flanking the roads appear to be islands in the snow. (Dugald)

FACING :~ Snow drifts over the runway at Churchill Airport, built during the Second World War at the same time as Fort Churchill. Today, the airport is an important transportation hub for ecotourists, research passengers, and goods destined for remote communities. (Churchill)

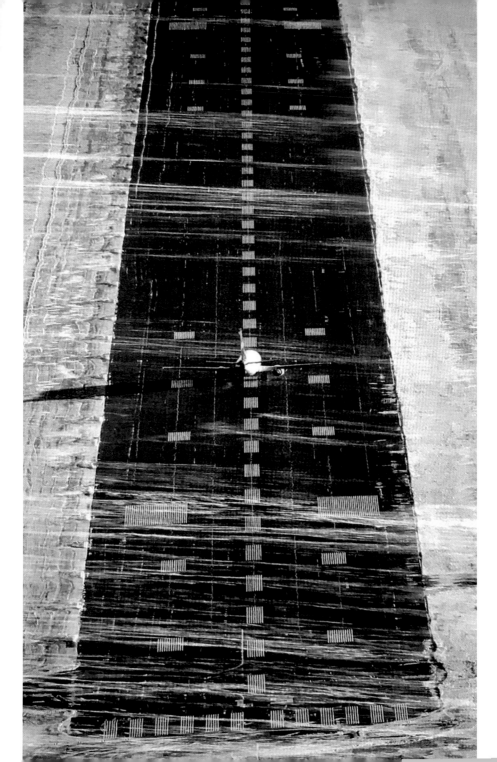

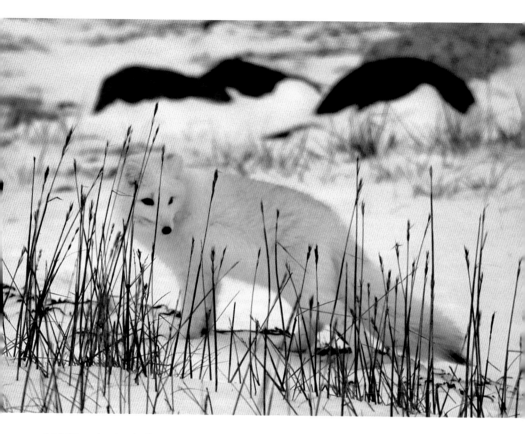

ABOVE :~ An Arctic fox pauses to listen. (Churchill)

FACING ABOVE :~ Jewel lichen covers Canadian Shield rock formations in festive colours. (Churchill)

FACING BELOW :~ Canada's only Arctic seaport, the Port of Churchill, services Churchill and remote communities along the Hudson Bay rail line. (Churchill)

OVERLEAF :~ Close to Hudson Bay, Otter Rapids is frozen in an embossed honeycomb pattern. (Near Churchill)

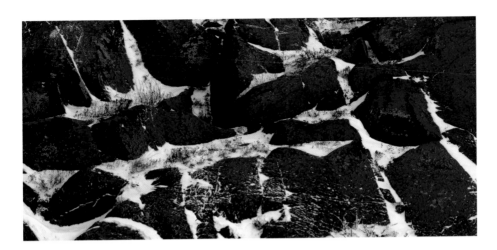

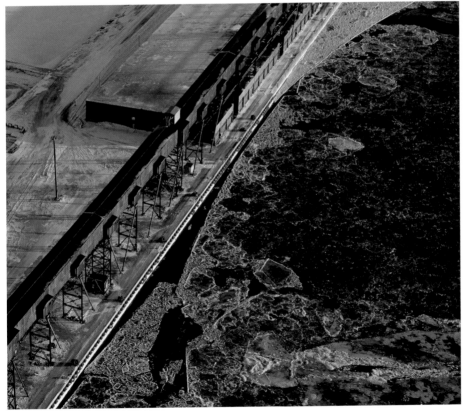

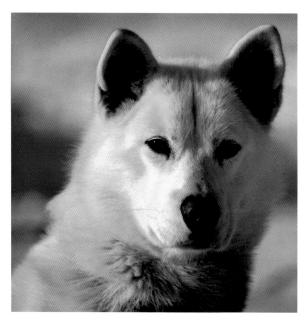

ABOVE :~ A hardy dog built for cold weather. (Churchill)

BELOW :~ A former airplane hangar painted by Winnipeg artist Kal Barteski glamorizes what is known locally as "polar bear jail." Bears that wander into town posing danger to the community are held safely in the facility's twenty-eight cells until Hudson Bay freezes over. They are then transported via helicopter to their hunting ground. (Churchill)

FACING ABOVE :~ The runners of a neglected sled are almost buried by drifting snow. (Churchill)

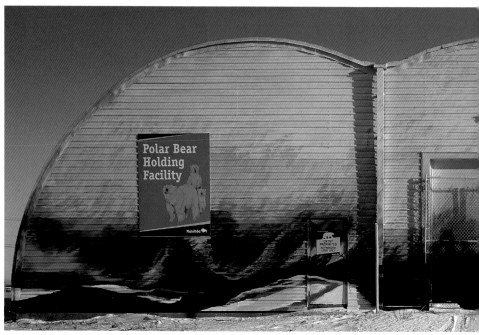

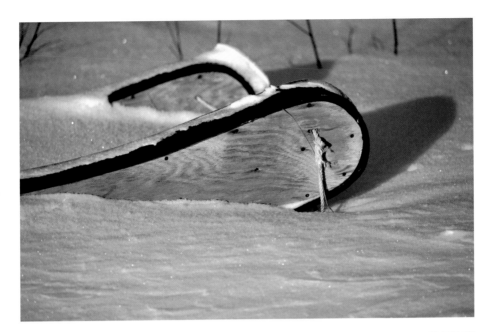

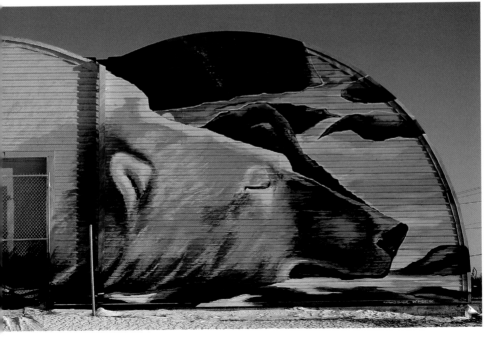

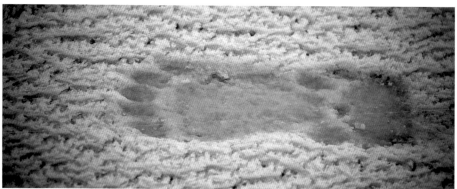

ABOVE ∾ *Footprint*, public art by Mandy van Leeuwen. Artists came from as far away as New Zealand to take part in the project, which explored the relationship between man and nature. (Churchill)

BELOW ∾ Paw print in the frozen ground. (Churchill)

FACING ∾ Male polar bears standing on their hind legs average 2.5 to 3 metres. Tundra Buggies sit on 1.7-metre-high tires and are, to everyone's delight, a curiosity for the sought-after beasts. (Churchill)

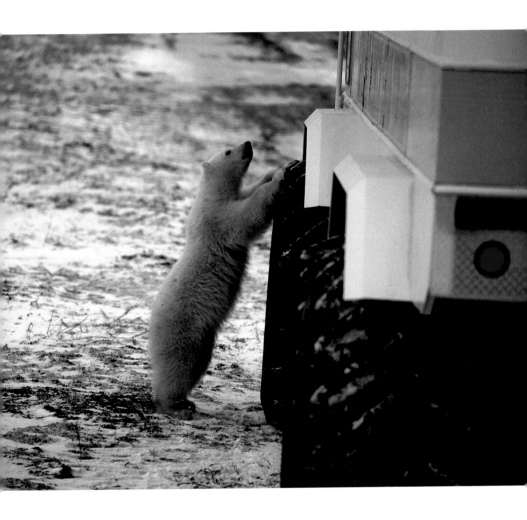

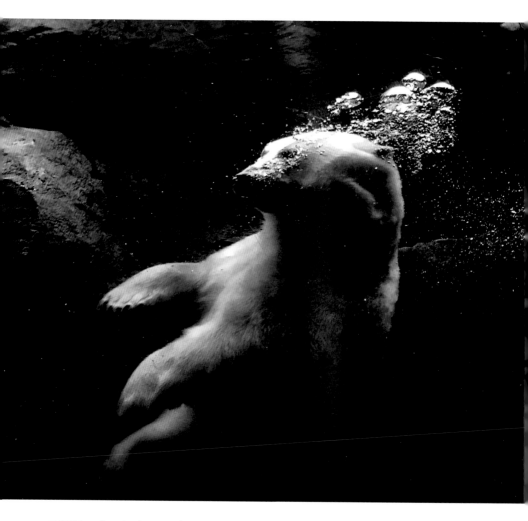

ABOVE :~ A polar bear under water. Males can grow to more than six hundred kilograms. (Churchill)

FACING ABOVE :~ A look back at the icy waters of Cape Merry reveals a colourful hut. The area was named Knight's Round Point in 1717 when it was a Hudson's Bay trading post. (Churchill)

FACING BELOW :~ The only ways to enter Churchill are via air or rail. The tiny town is famed for opportunities to observe polar bears, beluga whales, more than two hundred bird species, and the northern lights. (Churchill)

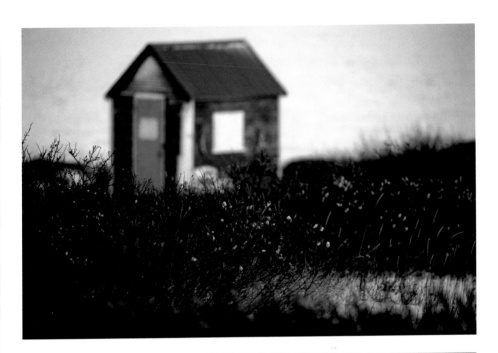

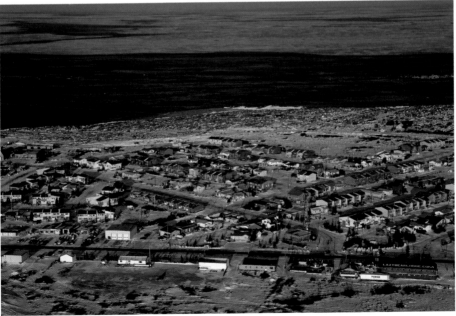

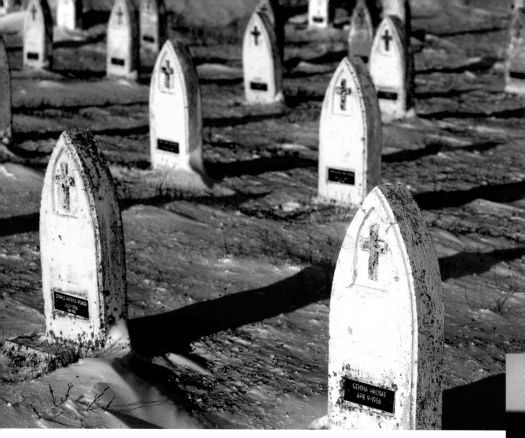

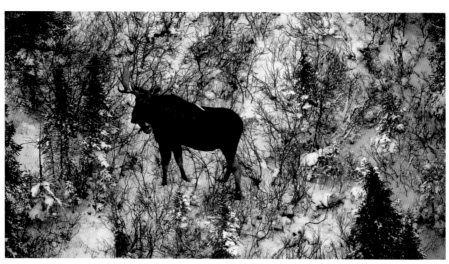

FACING ABOVE :~ Southeast of town, uniform tombstones mark a specific area of the Churchill Cemetery. (Churchill)

FACING BELOW :~ A wary moose seems to be deciding between "fight or flight." (Near Churchill)

BELOW :~ Hues of the setting sun tint peaks of translucent ice at the mouth of the Churchill River. (View from Kelsey Street, Churchill)

ABOVE :~ Suspended crystals form at the mouth of Churchill Lake, from which the Churchill River continues through Manitoba to Saskatchewan and central east Alberta, flowing over 1,609 kilometres. (Churchill)

FACING ABOVE :~ Nicknamed Miss Piggy for her ability to hold heavy loads, the Lamb Air Curtiss C-46 crash-landed in 1979. The wreck lies near the Institute of Arctic Ecophysiology. Fortunately, the crew survived. (Churchill)

FACING BELOW :~ To guard against attacks by the French, the Prince of Wales Fort was completed in 1771. However in 1782, a contingent of about three hundred French soldiers captured it, took prisoners, and blew up various structures. It has recently been restored and become a popular tourist destination. (Churchill)

OVERLEAF :~ Perched on the edge of Hudson Bay, Cape Merry watches over the mouth of Churchill River and on clear days offers views of Nunavut. (Churchill)

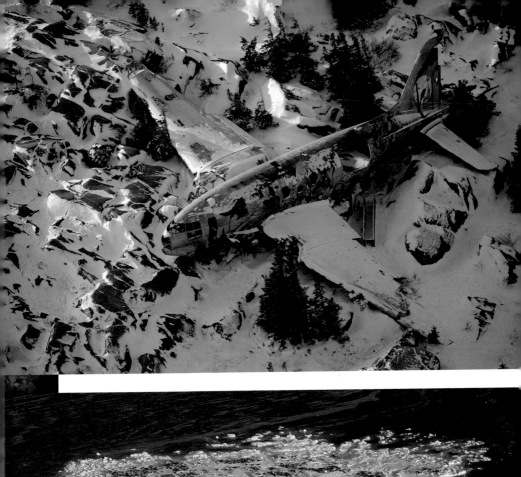

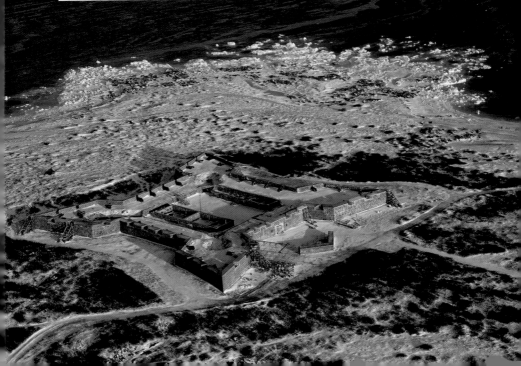

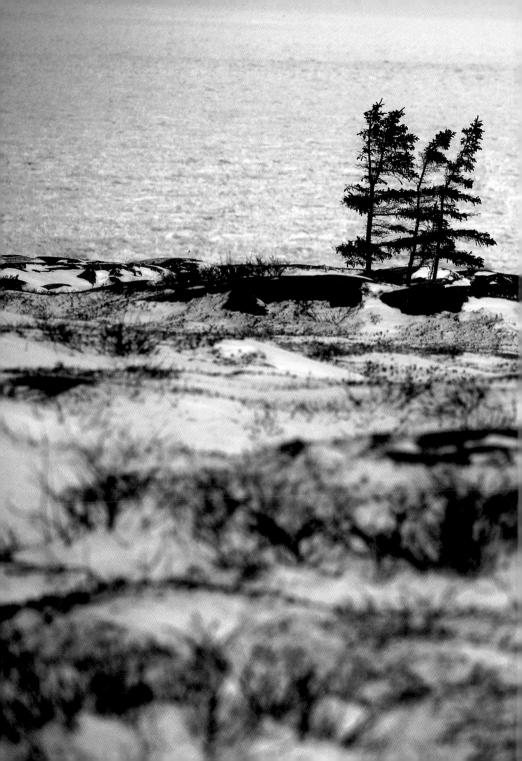

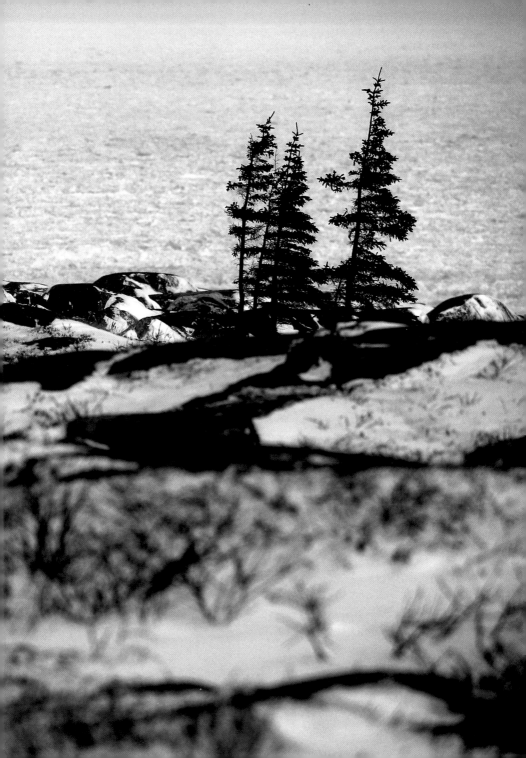

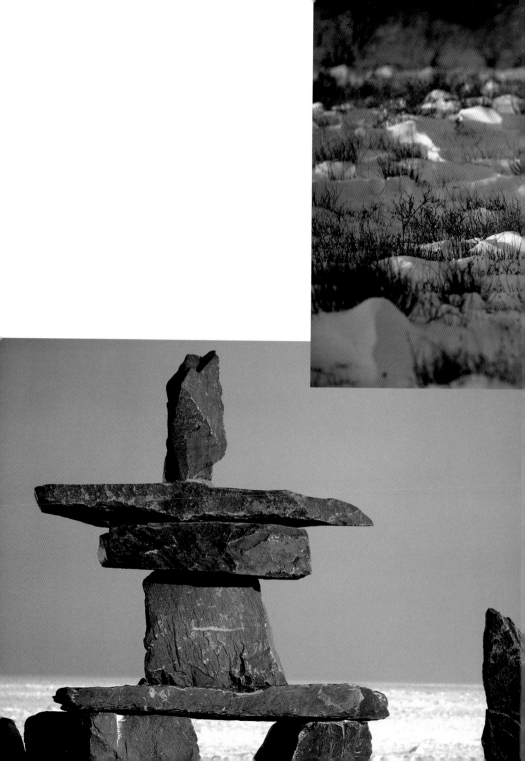

ABOVE :~ Dormant grasses rest under a blanket of sun-tipped November snow. (Churchill)

FACING :~ An Inuit inuksuk is a form of communication, and the stone landmarks vary in size and shape. (Churchill)

OVERLEAF :~ *Power of Nature* is a mural by Brazilian artist Arlin Graff made from colourful fragments. (Churchill)

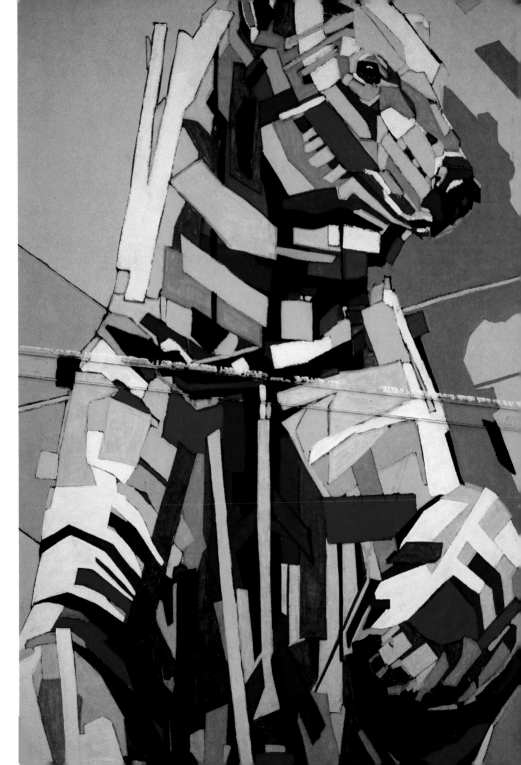